ART AND DESIGN

JANE BINGHAM

Published 2008 by
A & C Black Publishers Ltd.
38 Soho Square, London, W1D 3HB
www.acblack.com

Hardback ISBN 978-1-4081-0430-9

Paperback ISBN 978-1-4081-1092-8

This book is produced using paper that is made from wood grown in managed, sustainable forests. It is natural, renewable and recyclable. The logging and manufacturing processes conform to the environmental regulations of the country of origin.

Printed and bound in China by WKT.

All the internet addresses given in this book were correct at the time of going to press. The author and publishers regret any inconvenience caused if addresses have changed or sites have ceased to exist, but can accept no responsibility for any such changes.

Acknowledgements
The publishers would like to thank the following for their kind permission to reproduce their photographs:
Cover image: Bettmann/CORBIS. Pages: 4 Paul Seheult/Eye Ubiquitous/Corbis; Summerfield Press/CORBIS; 5 Summerfield Press/CORBIS; 6 Stefano Bianchetti/CORBIS; 7 Stefano Bianchetti/CORBIS; 9 Getty Images; 11 Ancient Art & Architecture Collection Ltd; 12 Michael Nicholson/CORBIS; 13 Bettmann/CORBIS; 14 Bettmann/CORBIS; 15 Francis G. Mayer/CORBIS; 16 Francis G. Mayer/CORBIS; 17 Bettmann/CORBIS; 18 Bettmann/CORBIS; 19 Bettmann/CORBIS; 20 Bettmann/CORBIS; 21 Oscar White/CORBIS; 22 Interpress/Sygma/Corbis; 23 M.C. Escher's portrait © 2008 The M. C. Escher Company-Holland. All rights reserved. www.mcescher.com; 24 Alain Nogues/CORBIS/Sygma; 25 Bettmann/CORBIS; 26 Rudolph Burckhardt/Sygma/Corbis; 27 Getty Images; 28 Rose Hartman/Corbis; 29 Rune Hellestad/Corbis; Toby Melville/PA Archive/PA Photos; 30 Hulton-Deutsch Collection/CORBIS; 31 Bettmann/CORBIS; Bettmann/CORBIS; 32 Arnold Newman/Liaison Agency/Getty Images 33 Reuters/CORBIS; 34 Colin McPherson/Corbis; Getty Images; 35 Michael Nicholson/Corbis; Bettmann/CORBIS; 36 Interfoto/AAA Collection; 37 Bettmann/CORBIS; 38 Keystone/CORBIS, Getty Images; 39 Bettmann/CORBIS; 40 Getty Images; 41 Hulton-Deutsch Collection/CORBIS; 42 Rune Hellestad/Corbis; Bettmann/CORBIS; 43 PACHA/CORBIS; 44 Getty Images; 45 Stephane Cardinale/People Avenue/Corbis

Contents

Giotto di Bondone

Giotto di Bondone was an Italian painter who mainly painted **frescoes**. He introduced **realism** into religious art, showing powerful emotions in his work.

Painting on walls

Giotto trained in the studio of the artist Cimabue, and he soon outshone his teacher. He worked as a painter in all over Italy, but his masterpiece was the series of frescoes in Padua, Italy.

Timeline

Follows Cimabue to Rome			Completes frescoes in the Arena Chapel, Padua, Italy	
c. **1267**	c. **1280**	**1287**	c. **1310**	**1337**
Born near Florence, Italy		Marries and starts a family		Dies 8 January in Florence, Italy

Sandro Botticelli

The Italian artist Sandro Botticelli was most famous for painting women. His masterpiece is the *Birth of Venus*.

A Renaissance painter

Botticelli lived for most of his life in Florence, Italy. He trained as a goldsmith and a painter. Botticelli was part of the early **Renaissance** movement in Italy. He painted religious subjects and scenes from Greek and Roman myths. His painting *Primavera* shows the Roman goddess of spring.

Find out more

Learn about Botticelli's life and see six of his most famous paintings at: www.ibiblio.org/wm/paint/auth/botticelli

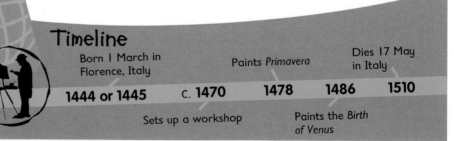

Timeline

Born 1 March in Florence, Italy		Paints *Primavera*		Dies 17 May in Italy
1444 or 1445	c. **1470**	**1478**	**1486**	**1510**
	Sets up a workshop		Paints the *Birth of Venus*	

4

Leonardo da Vinci

Leonardo da Vinci was the greatest figure of the Italian Renaissance. His interests ranged from art and architecture to maths and music. Many of his ideas were well ahead of his time.

Life and interests

Da Vinci grew up in Florence, Italy. At the age of 14, he began studying to become a sculptor and painter. He spent most of his life in Florence and Milan and worked for many different **patrons**. For the last three years of his life, he worked for the king of France. Da Vinci had an incredible range of talents. He was an architect, artist, and sculptor, but also an engineer, inventor, scientist, musician, and mathematician. He was fascinated by the world around him and kept a series of notebooks, which he filled with notes and sketches.

What he said

❝ Art is never finished, only abandoned. ❞

Find out more

Take a look at some of da Vinci's greatest works at:
www.ibiblio.org/wm/paint/auth/vinci

Find out all about da Vinci at:
www.mos.org/leonardo

This site explains some of the details on the pages of Leonardo's notebooks:
www.vam.ac.uk/leonardo

Timeline

Born 15 April in Florence, Italy	Starts work on the *Mona Lisa*		Dies 2 May in Amboise, France	
1452	**1498**	**1503**	**1516**	**1519**
	Finishes painting *The Last Supper*		Moves to France to work for the French king	

Great achievements

Da Vinci produced many paintings and sculptures, and also drew detailed plans for bridges, forts, and weapons. His most famous paintings are the *Mona Lisa* and *The Last Supper*. He also invented a flying machine and made detailed studies of the human body.

How did he die?

Da Vinci may have died in the arms of King Frances I of France.

Michelangelo Buonarroti

Michelangelo Buonarroti was one of the leading figures of the Italian Renaissance. He was a talented architect, sculptor, painter, and poet.

What he said

❝ Every block of stone has a statue inside it and it is the task of the sculptor to discover it. ❞

How did he die?

Michelangelo died from a fever, aged 88.

Find out more

This website tells the story of Michelangelo's life:
www.michelangelo.com

Take a look at some of Michelangelo's greatest works at:
www.ibiblio.org/wm/paint/auth/michelangelo

Find out more about Michelangelo at:
www.wga.hu/bio/m/michelan/biograph.html

A painter and a sculptor

When Michelangelo was just six years old his mother died. He spent the rest of his childhood with a stonecutter's family. From the age of 13, he studied to be a painter and then a sculptor. As a teenager, he trained for two years in the Medici Palace in Florence, Italy. Michelangelo worked mainly in Florence and Rome, and many of his works were paid for by the Pope. He was fascinated by human anatomy, and made secret trips to a hospital to draw the bodies of the dead. He was a colourful character who did not care about what he ate or how he dressed.

Timeline

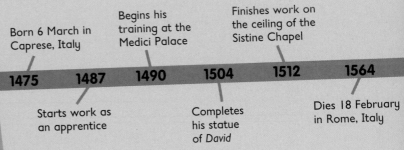

1475 Born 6 March in Caprese, Italy

1487 Starts work as an apprentice

1490 Begins his training at the Medici Palace

1504 Completes his statue of *David*

1512 Finishes work on the ceiling of the Sistine Chapel

1564 Dies 18 February in Rome, Italy

Great works

Michelangelo's most famous sculptures are his marble statue, *David*, and his *Pietà* (a sculpture of the Virgin Mary holding the dead Christ). He also painted the ceiling of the Sistine Chapel. It took him four years to complete the ceiling.

Raphael Sanzio

Raphael Sanzio was one of the great masters of the Italian Renaissance. He is best-known for his perfectly balanced compositions and his graceful but expressive figures.

What the tomb said

" Here lies the famous Raphael by whom Nature feared to be outdone while he lived. "

Paintings for the Pope

Raphael was the son of a painter. As a young boy, he helped his father in his workshop, but later he became an apprentice to the painter, Perugino. In his twenties, Raphael worked in Florence, studying the art of Leonardo da Vinci and Michelangelo. For the last 12 years of his life he lived in Rome. There he mainly worked for the Pope, painting frescoes, portraits, and religious subjects. Raphael was a successful artist. He ran a workshop with more than 50 assistants. As well as producing paintings, he made hundreds of drawings and also designed buildings.

How did he die?

Raphael died from a fever when he was just 37 years old.

Timeline

Born 28 March or 6 April in Urbino, Italy

Moves to Rome, Italy

Dies 6 April in Rome

1483 **1504** **1508** **1514** **1520**

Starts working in Florence, Italy

Completes the *Sistine Madonna*

Fascinating paintings

Raphael is especially famous for his paintings of the **Madonna**. Art critics rate his *Sistine Madonna* as one of the greatest paintings of the Renaissance. The work has fascinated people for centuries because of the troubled expressions of the Virgin Mary and Child.

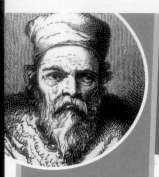

Michelangelo Caravaggio

Michelangelo Caravaggio was a master of painting shadows. His works of art shocked the public with their realism and violence. He lived a short life.

Artist and rebel

Caravaggio was named after the place where he grew up. His parents died when he was young. At the age of 13, he became an apprentice to a painter. When he was 20, he moved to Rome, but he was exiled from the city after killing a man. He died four years later.

Find out more

This website has an illustrated account of the artist's life. Click on English Direct:
http://home.worldonline.dk/lfmat/

Timeline

Moves to Rome

Survives a knife attack in Naples, Italy

1571	1592	1606	1609	1610
Born 29 September in Milan, Italy		Kills a man and is exiled from Rome		Dies 18 July in Porto Ercole, Italy

Artemisia Gentileschi

Artemisia Gentileschi was one of the very few female artists of her generation. She had a very hard life and was not afraid to paint violent scenes.

A remarkable woman

The daughter of a painter, Gentileschi learned to paint religious and historical scenes. As a young woman, she was accused of lying and was cruelly tortured. For most of her life Gentileschi was extremely poor, but she never stopped painting. For a short time, she worked in England.

Find out more

This website tells the story of Gentileschi and includes examples of her art:
www.wga.hu/bio/g/gentiles/artemisi/biograph.html

Timeline

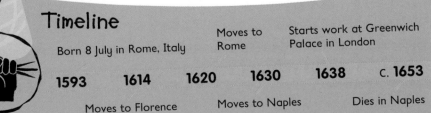

Born 8 July in Rome, Italy

Moves to Rome

Starts work at Greenwich Palace in London

1593	1614	1620	1630	1638	c. 1653
	Moves to Florence		Moves to Naples		Dies in Naples

Rembrandt van Rijn

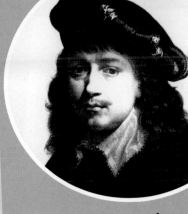

The Dutch painter and printmaker Rembrandt van Rijn was an outstanding artist. He painted portraits and landscapes and was a master of colour, light, and shade.

A hard life

Rembrandt was the son of a Dutch miller. He went to university, but he left early to study as a painter. When he was about 18 years old, Rembrandt opened his own studio and began to teach students. Seven years later, he moved to Amsterdam, where he became the leading painter in Holland. He received many **commissions** for portraits and for paintings of religious subjects. Rembrandt suffered many personal tragedies. Three of his children died. He was not good at managing money and by the end of his life he was very poor.

What he said

❝ Choose only one master – Nature. ❞

Find out more

This fantastic website about Rembrandt has some pages about his self-portraits:
www.rembrandtpainting.net

Find out more about Rembrandt's life and work at:
www.ibiblio.org/wm/paint/auth/rembrandt

Timeline

Born 15 July in Leiden, Holland

Moves to Amsterdam

Dies 4 October in Amsterdam, Holland

1606 c. **1624** **1631** **1642** **1669**

Opens a studio in Leiden

Paints *The Night Watch*

Famous works

Two of Rembrandt's most famous paintings are *The Night Watch*, which depicts a group of guardsmen, and *The Anatomy Lesson*, in which a doctor shows how to dissect a dead body. Rembrandt is also known for his series of self-portraits. Some of them show him posing in historical costumes or pulling faces at himself. Rembrandt painted more than 50 self-portraits.

How did he die?

Rembrandt died in poverty, aged 63. His son, Titus, died the previous year, aged just 27.

Johannes Vermeer

Johannes Vermeer was a Dutch painter who specialized in portraits and **domestic** scenes. His best-known work is the *Girl with a Pearl Earring*.

What the critics said

❝ Vermeer was a master of light. ❞

How did he die?

Vermeer died aged 43. He left his family with many debts.

The genius of Delft

Vermeer's father was a silk weaver and art dealer, and he probably also dealt in paintings. Vermeer remained in his home town of Delft for all of his life. He married young and had 13 children. As a young man, Vermeer was apprenticed to a local artist. He soon became an established portrait painter, producing work for wealthy patrons. However, he worked very slowly, so he never managed to make enough money to support his family. He was often in debt, and his family had to live in his mother-in-law's house.

Timeline

Born in Delft, Holland

1632

1653
Marries Catharina Bolnes

Elected head of the Painters' Guild in Delft

1662

1675
Dies in Delft

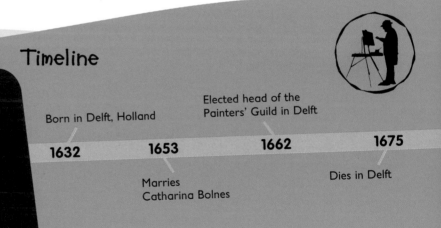

Vermeer's portraits

Almost all of Vermeer's portraits are painted indoors and feature sunlit rooms with tiled floors. Many of his works show wealthy people in fine clothes, but others show servant girls. *Girl with a Pearl Earring* is famous for the painter's treatment of light and the girl's mysterious expression.

Francisco Goya

Francisco Goya was a Spanish painter and printmaker, who has been called "the father of modern art". He painted brilliant portraits and scenes of terrible suffering in war.

A great talent

Goya was the son of a craftsman. At the age of 14 he was apprenticed to a local painter. He later studied in Madrid, Spain, and in Rome, Italy. For five years, Goya worked as a tapestry designer before he became a painter at the royal Spanish court. Goya was a successful court painter. In 1792, however, he had a serious illness, which left him deaf. From then on, he often painted dark images of suffering and pain. In 1824, Goya quarrelled with the new king of Spain so he moved to France.

What he said

66 The dream of reason produces monsters. 99

How did he die?

Goya died from a **stroke** aged 82.

Timeline

1746	1783	1792	1814	1824	1828

Born 30 March in Fuendetodos, Spain

Has a serious illness and becomes deaf

Moves to France

Starts work as a court painter

Paints *The Third of May 1808*

Dies 16 April in Bourdeaux, France

Find out more

Find out more about Goya's life and work at:
www.imageone.com/goya

Read the story of the artist's life and see some examples of his paintings:
www.ibiblio.org/wm/paint/auth/goya

This site has a timeline of Goya's life:
www.eeweems.com/goya/bio_timeline.html

Images of war

Goya is famous for his portraits of members of the Spanish court, but he is also known for his images of war. Many art critics think that his masterpiece is *The Third of May 1808*. This disturbing painting shows a group of rebels being shot down by a line of soldiers during the French occupation of Spain in 1808.

J. M. W. Turner

J. M. W. Turner was an English landscape painter, who painted in oils and watercolours. Turner was fascinated by the effects of weather, and he developed a very individual style.

What he said

66 My job is to draw what I see, not what I know. 99

How did he die?

Turner died at the age of 76. He continued to work until just before his death.

A life in art

Turner was the son of a barber and wigmaker from London. The young Turner showed an early talent for art, and he earned money by drawing his father's customers. At the age of 14, he went to study at the Royal Academy of Art in London. As an adult, Turner was supported by some wealthy patrons. He never married, and he lived with his father for 30 years. Turner travelled widely, painting in France, Switzerland, and Italy.

Find out more

Learn about Turner's life and art and view some famous images:
www.ibiblio.org/wm/paint/auth/turner

Take a virtual tour of Turner's paintings at:
www.liverpoolmuseums.org.uk/walker/exhibitions/turner

Timeline

1775	1789	1802	1844	1851
Born 23 April in London, England	Studies at the Royal Academy in London	Sets off on his first journey abroad	Paints *Rain, Steam and Speed*	Dies 19 December in London

Turner's paintings

Turner painted historical, **classical**, and religious scenes, but he is best-known as a landscape artist. As he grew older, his painting style became less well defined, and he used colour in daring ways. One of his most famous works is *Rain, Steam and Speed*, painted in 1844. The painting shows a steam train crossing a bridge on a rainy day.

Auguste Rodin

Auguste Rodin was a French sculptor who produced large-scale, dramatic works. His bronze figure *The Thinker* is one of the world's most famous sculptures.

A sculptor's life

Rodin came from a poor family, and grew up in Paris, France. As a boy, he developed a strong interest in sculpture, but he was not accepted to study at the leading Paris Academy. He struggled to survive as a sculptor until he visited Italy. There, he was inspired by the work of Michelangelo. In 1877, Rodin exhibited a large male figure called *The Age of Bronze*. The figure amazed people and he started to receive more commissions. By the end of his life he was very successful. Rodin created thousands of busts (sculptures showing just the upper body) and figures, and he was also a painter and printmaker.

What he said

" I invent nothing, I rediscover. "

Find out more

Take a virtual tour of Rodin's works at:
www.rodinmuseum.org

Find out more about Rodin's life and art at:
www.ibiblio.org/wm/paint/auth/rodin

Explore another great site about Rodin's life and work:
www.cantorfoundation.org/Rodin/rbioe.html

Timeline

Born 12 November in Paris, France

Exhibits *The Age of Bronze* in Belgium

Dies 17 November in Meudon, France

1840 **1875** **1877** **1889** **1917**

Visits Italy and is inspired by Michelangelo

Finishes *The Thinker*

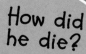

How did he die?

Rodin died from **influenza**, aged 77. He had married just two weeks earlier.

Famous works

Rodin is best-known for *The Thinker*, which shows a seated man with his chin resting on one of his hands, and *The Kiss*, which shows a man and woman in a passionate embrace. Rodin also sculpted many portraits and some groups of figures, such as *The Burghers of Calais*.

13

Claude Monet

Claude Monet was one of the leaders of the **Impressionist** movement. He is best-known for his landscapes and for his large paintings of lily ponds.

What he said

66 Colour is my day-long obsession, joy and torment. 99

How did he die?

Monet died from lung cancer, aged 86.

An Impressionist's life

Monet was the son of a grocer. As a boy he was good at drawing caricatures and covered his school books with cartoons of his teachers. Monet studied in Paris and began to paint landscapes and everyday scenes. He played an important part in developing the Impressionist style, along with Pierre-Auguste Renoir. When he was in his forties, Monet bought a house at Giverny and created a Japanese-style water garden. He painted hundreds of images of his garden. Towards the end of his life, Monet started to go blind. In his final years, he painted large-scale pictures of the water lilies floating on his garden ponds.

Timeline

Born 14 November in Paris, France

Develops the Impressionist style with Renoir

Dies 5 December in Giverny, France

1840 **1859** **1869** **1883** **1926**

Studies art in Paris

Moves to Giverny

New impressions

Monet pioneered a new approach to painting. He rejected realism, aiming to create a personal impression of what he saw. He used bright colours and short, confident brushstrokes. He was fascinated by the effects of light. He painted a series of haystacks at different times of day, and in different seasons. Many painters followed Monet's new Impressionist style.

Mary Cassatt

Mary Cassatt was an American artist who painted in the Impressionist style. She produced many works of art, specializing in studies of women and children.

An American in France

Cassatt was the daughter of a wealthy American banker. In 1865, she moved to Paris to study art and spent the rest of her life in France. She met and became friends with some of the Impressionist artists, including Edgar Degas, and was invited to exhibit with them. Cassatt never married, but she spent a lot of time looking after members of her family. At the age of 70, she started to go blind and was forced to give up painting.

What she said

" I am independent! I can live and I love to work. "

When did she die?

When Cassatt died, aged 82, she was almost blind.

Timeline

Born 22 May in Pennsylvania, USA

Exhibits work with the Impressionists

Dies 14 June in Chateau de Beaufresne, France

1844	1865	1879	1914	1926

Moves to Paris

Stops painting because of failing eyesight

Find out more

Explore the life, times, and work of Cassatt at:
www.metmuseum.org/explore/cassatt/html/index.html

Take a virtual tour of Cassatt's prints at:
www.nga.gov/collection/gallery/cassatt/cassatt-main1.html

Find out more about Cassatt's life at:
www.tfaoi.com/newsmu/nmus1d.htm

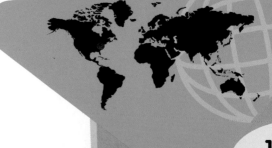

Cassatt's style

Cassatt produced oil paintings, pastel drawings and prints. At first she worked in a realistic style, but after she met the Impressionists her style became looser. She was also strongly influenced by Japanese art. Many of her images show domestic scenes, such as a tea party or mothers giving their children a bath.

Paul Gauguin

Paul Gauguin was one of the leading **Post-Impressionist** artists. He was a self-taught painter, with a bold, colourful style. He spent his last years living on the islands of the South Pacific.

What he said

66 *I shut my eyes in order to see.* 99

How did he die?

Gauguin died of a heart attack, aged 54.

A life on the move

Gauguin was born in Paris, France, but lived in Peru until he was seven years old. He joined the merchant navy as a young man and travelled widely, before settling down to work as a banker. In 1883, he lost his job and decided to devote all his time to art. He painted in Brittany, France, and spent a short time with Vincent van Gogh (⇨p17) in Arles. In 1891, Gauguin travelled to the South Pacific island of Tahiti. He spent most of the rest of his life living on one island or another, painting and learning more about the different way of life there. He died 12 years later on the Marquesas Islands in the South Pacific.

Find out more

Find out more about Gauguin's life and look at some examples of his work at:
www.ibiblio.org/wm/paint/auth/gauguin

Take a virtual tour of Gauguin's paintings at:
www.nga.gov/collection/gallery/gg82/gg82-main1.html

Look at great examples of Gauguin's work at:
www.expo-gauguin.net

Timeline

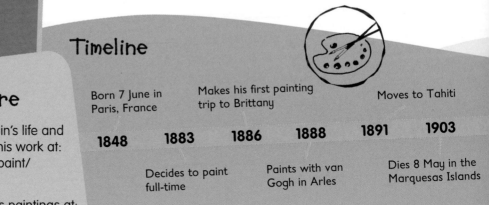

1848	1883	1886	1888	1891	1903
Born 7 June in Paris, France	Decides to paint full-time	Makes his first painting trip to Brittany	Paints with van Gogh in Arles	Moves to Tahiti	Dies 8 May in the Marquesas Islands

Gauguin's style

Gauguin's early work was influenced by the Impressionists. He painted striking scenes, using simple shapes, bold outlines, and vivid colours. The native art of the South Pacific islands had a powerful impact on Gauguin's style, and his later pictures often include personal and religious **symbols**.

Vincent van Gogh

The Dutch artist Vincent van Gogh painted portraits, landscapes, and still-life compositions in a very individual style. His works include *Starry Night* and *Sunflowers*. He was a tormented genius, who suffered from periods of mental illness.

A troubled life

Van Gogh was the son of a Dutch **minister**. He took up full-time painting when he was 27. For the next six years, van Gogh studied art in Belgium and Holland, before arriving in Paris, France. In 1888, van Gogh moved to Arles in the south of France. Paul Gauguin (⇨p16) visited his house at Arles, but the two artists argued and van Gogh cut off his own ear. Following a period of mental illness, van Gogh went to live in a special hospital at Saint Rémy. After leaving the hospital, he lived in Auvers, near Paris, for two months, before committing suicide.

What he said

66 I dream my painting, and then I paint my dream. 99

Find out more

This site presents works by van Gogh, organized by themes:
www.ibiblio.org/wm/paint/auth/gogh

Take a guided tour of van Gogh's paintings at the National Gallery website:
www.nationalgallery.org.uk/collection/features/sunflowers/default.htm

Timeline

Born 30 March in Zundert, Holland

Moves to Arles

Dies 29 July in Auvers, France

1853 **1880** **1888** **1889** **1890**

Starts his career as an artist

Enters the asylum at Saint Rémy

How did he die?

Van Gogh shot himself in a field and died two days later. He was just 37 years old.

Van Gogh's art

Van Gogh's art shows the influence of Impressionism and Japanese art. It is remarkable for its expressive use of colour and brushwork. Van Gogh is grouped with the Post-Impressionists, but his work is highly individual. He is one of the best-known painters of modern times.

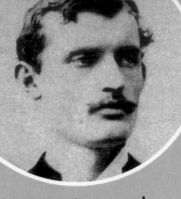

Edvard Munch

Edvard Munch was a Norwegian painter and printmaker, who explored themes of love, pain, and death in his work. His most famous painting is *The Scream*.

What he said

66 For as long as I can remember I have suffered from a deep feeling of anxiety which I have tried to express in my art. 99

How did he die?

Munch died from **pneumonia** just after his 80th birthday.

Pain and suffering

As a child, Munch was often ill. His mother died when he was five years old, and his favourite sister died when he was 15. Another sister suffered from mental illness. Munch started to study engineering, but later changed to art. He spent many years living in Paris, France, and Berlin, Germany, where he was part of a group of artists and writers. Munch suffered from severe depression, and in 1908 he spent eight months in a clinic in Denmark, before returning to Norway, where he lived for the rest of his life. Munch once said, "Sickness and madness and death were the angels that stood at my cradle, and they have followed me throughout my life."

Timeline

1863	1868	1877	1893	1908	1944
Born 12 December in Adalsbruck, Norway	Munch's mother dies		Munch's favourite sister dies / Paints *The Scream*	Spends 8 months in a clinic	Dies 23 January in Ekely, Norway

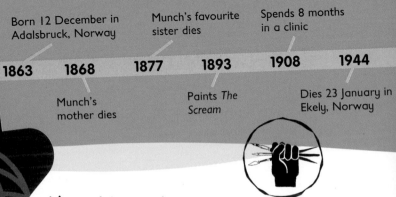

Munch's art

Munch's early pictures were realistic in style, but he was influenced by the Post-Impressionists. His paintings grew simpler and bolder. By the time he painted *The Scream*, Munch was working in an **Expressionist** style.

Henri Matisse

Henri Matisse was a painter, printmaker, and sculptor. He is famous for using vivid colours and simple shapes in his works of art.

A long life

Matisse came from a middle-class family. He studied law before he discovered painting. While he was recovering from illness in 1889 his mother encouraged him to take up painting. As a young artist, he was influenced by the bold style of the Post-Impressionists, and he began to use vivid colours. When he was 36, he met Pablo Picasso (⇨p20), and they began a lifelong friendship. Matisse produced drawings, prints, sculptures, and stained glass, but he mainly concentrated on painting. In his seventies, he had cancer and had to use a wheelchair. From then on, he mainly worked on "cut-outs". These were semi-**abstract** works made from pieces of coloured paper.

What he said

" Creativity takes courage. "

How did he die?

Matisse died of a heart attack at the age of 84.

Timeline

1869	1889	1905	1909	1941	1954
Born 31 December in Le Cateau-Cambrésis, France	Discovers painting, aged 21	Begins his friendship with Picasso	Paints his second version of *La Danse*	Starts to concentrate on cut-outs as a result of illness	Dies 3 November in Nice, France

Find out more

This site has lots of information about Matisse's life and art:
www.ibiblio.org/wm/paint/auth/matisse

Take a virtual tour of paintings by Matisse at the Pompidou Centre website:
www.centrepompidou.fr/education/ressources/ENS-matisse-EN/ENS-matisse-en.htm

Explore the website of the Matisse Museum in Nice:
www.musee-matisse-nice.org

You can compare the art of Matisse and Picasso:
www.matisse-picasso.com/artists

Matisse's art

Matisse was a leading member of the Fauvists. This group of artists painted in very bold colours. Matisse painted portraits, landscapes, and still-lifes, and he often showed nudes. One of his best-known works is *La Danse*, a large-scale painting showing a group of naked women dancing in a circle.

Pablo Picasso

Pablo Picasso was a Spanish painter and sculptor and one of the leaders of the **Cubist** movement. Many people see Picasso as the most important figure in 20th-century art.

What he said

66 Every child is an artist. The problem is how to remain an artist once we grow up. 99

How did he die?

Picasso died from a heart attack while he was entertaining friends for dinner. He was 91.

Find out more

Find out more about Picasso's life and work at:
www.tamu.edu/mocl/picasso

Take a tour of the Picasso Museum in Barcelona:
www.museupicasso.bcn.es/eng/index_eng.htm

This site explores the background and meaning of Picasso's "Guernica":
www.pbs.org/treasuresoftheworld/a_nav/guernica_nav/main_guerfrm.html

A great experimenter

Picasso's father was an art professor who helped to train his son from a very early age. At the age of 16, Picasso left home to study art in Madrid, Spain, but he soon abandoned his course. When he was 21, he moved to Paris, France, where he made friends with artists, musicians, and poets. From then on, he divided his time between France and Spain. He became friends with the French painter, Georges Braque, and they worked together for a while.

Timeline

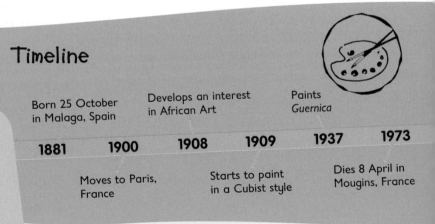

Born 25 October in Malaga, Spain		Develops an interest in African Art		Paints *Guernica*	
1881	**1900**	**1908**	**1909**	**1937**	**1973**
	Moves to Paris, France		Starts to paint in a Cubist style		Dies 8 April in Mougins, France

Picasso worked in many different styles throughout his long life. In his late twenties, he became interested in African art. This helped him to develop his ideas on Cubism with Braque. Most of his works were in the Cubist style.

Famous works

Picasso's best-known work is *Guernica*. This large-scale painting represents the horrors of war. Picasso is also famous for his Cubist portraits of women and his images of bulls and the dove of peace.

Edward Hopper

Edward Hopper was an American painter and printmaker, whose work shows the bleakness of modern life. His paintings often feature all-night cafes, petrol stations, and seaside hotels.

Life and art

Hopper was the son of a shopkeeper in a small American town. He studied art in New York and Europe for more than 10 years. Hopper did not sell any of his paintings at first. By the time he reached his forties, however, he had developed his own very individual style and his paintings began to sell. Hopper had a stormy marriage to Jo Nivison, another painter. The couple lived in an apartment in New York City and had a second home on the coast.

What he said

"If you could say it in words there would be no reason to paint.**"**

Find out more

Find out more about Hopper's life and work at:
www.ibiblio.org/wm/paint/auth/hopper

This site presents a Hopper scrapbook, organized by themes:
http://americanart.si.edu/hopper

You can view a short slide show of Hopper and his art at:
www.mfa.org/hopper

Timeline

Born 22 July in Nyack, New York, USA

Paints *The House by the Railroad*, his first mature work

Dies 15 May in New York City

1882 **1924** **1925** **1942** **1967**

Marries Jo Nivison

Paints *Nighthawks*

Images of loneliness

Hopper showed lonely figures in simplified settings, with strong lighting effects. One of his best-known paintings is *Nighthawks*, which shows people in a brightly lit cafe staring out into the dark night. Hopper is sometimes described as an American Realist, but his work is unlike that of any other artist. He loved films, and many of his paintings were influenced by the art of the cinema.

How did he die?

Hopper died in his studio at the age of 84.

Marc Chagall

The Russian artist Marc Chagall created dream-like images in his paintings. His work often shows scenes from his own life, and many of his paintings include figures such as flying people and animals.

What he said

66 If I create from the heart, nearly everything works; if from the head, almost nothing. 99

How did he die?

Chagall died at the age of 97. He was still painting in his nineties.

Russia and France

Chagall was born into a poor Jewish family from Russia. He studied art in St. Petersburg and at the age of 23 he travelled to Paris, France. Four years later he returned to Russia, where he married his childhood sweetheart, Bella. At the age of 36, Chagall returned to Paris. He spent most of the rest of his life in France. In his sixties, he moved to the south of France, where he lived for the next 35 years. By the end of his life, he had become world famous.

Timeline

Born 7 July in Liozna, Russia (now Belarus)

Marries Bella

Settles in the South of France

| 1887 | 1910 | 1915 | 1923 | 1950 | 1985 |

Moves to Paris, where he stays for four years

Returns to Paris

Dies 28 March in Saint-Paul de Vence, France

Painting dreams

Chagall worked in a wide range of media, producing paintings, prints, murals, stained-glass windows, theatre sets, costume designs, and book illustrations. He developed a highly individual style for the dream-like scenes in his works. Chagall's work was inspired by Russian folk art and his Jewish faith, but he was also influenced by modern art movements.

M. C. Escher

Escher was a Dutch graphic artist who explored mathematical ideas in his work. Many of his drawings feature visual puzzles, such as a never-ending flight of steps.

Escher's life

Escher was the son of a Dutch engineer. At college, he began to study architecture, but he soon changed to art. At the age of 24, Escher set off to explore Europe. He got married in Italy and lived there for the next ten years. During World War II, Escher and his family moved several times, but they finally settled in Holland. Escher spent his time studying maths and making drawings, prints, and **woodcuts**. He also wrote papers about his mathematical ideas.

What he said

" Are you really sure that a floor can't also be a ceiling? "

How did he die?

Escher died aged 73 after a long illness.

Timeline

Born 17 June in Leeuwarden, Holland

Marries and settles in Italy

Dies 27 March in Laren, Holland

1898 **1922** **1924** **1941** **1972**

Starts travelling in Europe

Returns to Holland

Find out more

Take a virtual tour of Escher's art at:
www.mcescher.com/Gallery/gallery.htm

Find out more about Escher's life at:
www.mcescher.com/Biography/biography.htm

This site includes a video clip of Escher at work:
www.mcescher.com/Film/escheratworkuk.htm

Maths and art

Escher had no training in mathematics, but he was fascinated by the subject. Many of his drawings explore ideas of space. They show buildings with ceilings that seem to turn into floors, depending on your point of view. Escher also made pictures from tessellating shapes. These are repeated shapes that fit together perfectly, like a set of tiles.

Salvador Dalí

Salvador Dalí was a Spanish artist who worked in the **Surrealist** style. His paintings often include mysterious and disturbing images.

What he said

66 People love mystery, and that is why they love my paintings. 99

How did he die?

Dalí died of a heart attack at the age of 84.

A great eccentric

Dalí was the son of a lawyer. As a young boy, he showed a great talent for art. When he was just 13 years old his father organized an exhibition of his work. Dalí studied art in Madrid, Spain, but he was expelled just before his final exams. As a young man, he joined a group of artists and writers who worked in the Surrealist style. Dalí was a Surrealist for the rest of his life. He was a great showman, who loved to dress in eccentric clothes. His wife Gala died in 1982. A couple of years later, Dalí suffered serious burns at a fire in his home.

Timeline

1904	1917	1931	1934	1989
Born 11 May in Figueres, Spain	Dalí's father holds the first exhibition of his drawings	Paints *The Persistence of Memory*	Marries his Russian wife Gala	Dies 23 January in Figueres, Spain

Find out more

Take a virtual tour of Dalí's art at:
www.daliweb.tampa.fl.us/collection.htm

Explore another virtual gallery of Dalí's work:
www.virtualdali.com

Find about Dalí's life, year by year:
www.salvador-dali.org/dali/en_biografia.html

Surreal images

Dalí was a painter, sculptor, photographer, and film-maker. His paintings show fantasy scenes, but they are painted in a realistic style that was influenced by Renaissance art. Dalí's art is full of symbols, and many of his works contain religious icons. One of his most famous works is *The Persistence of Memory*. It shows soft watches and clocks hanging over objects as though they are melting.

Frida Kahlo

Frida Kahlo was Mexican artist whose colourful paintings were strongly influenced by folk art. She painted dramatic self-portraits that expressed her own pain and suffering.

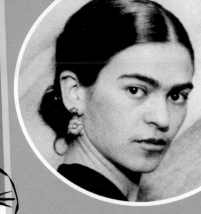

Pain and adventure

Frida Kahlo grew up during the Mexican Revolution. As a young girl, she witnessed many acts of violence. She began to study to become a doctor when she was 15. At the age of 17, Kahlo was involved in a road accident. She suffered serious injuries, including a broken back, and had to stay completely still for many months. She realized that she would have to give up her medical studies. During her recovery she began to paint, and decided that she would become an artist instead.

What she said

66 I paint myself because I am often alone and I am the subject I know best. 99

Find out more

Find out about the life and work of Kahlo at:
www.fridakahlo.com

View the Tate Modern's virtual exhibilion of Kahlo's art at:
www.tate.org.uk/modern/exhibitions/kahlo

Timeline

Born 6 July in Coyoacán, Mexico

Paints her first self-portrait

Begins her friendship with Trotsky

1907 **1925** **1926** **1929** **1937** **1954**

Seriously injured in a road accident

Marries Diego Rivera

Dies 13 July in Coyoacán, Mexico

Kahlo had a very stormy marriage to the Mexican painter Diego Rivera. She was also an active member of the **Communist** party and a friend and lover of Leon Trotsky. As a result of her accident, Kahlo was in pain for the rest of her life and had more than 30 operations.

Portraits of pain

Kahlo is best-known for her self-portraits. She was inspired by Mexican folk art but also by the Surrealist movement. Kahlo's paintings show her physical and emotional pain.

How did she die?

Kahlo died aged 47. The official cause of death was a blood clot in the heart.

Jackson Pollock

Jackson Pollock was an American abstract painter who developed the technique of "action painting". He made "drip paintings", covering his canvases with splashes and drips of paint.

What he said

66 The painting has a life of its own. I try to let it come through. 99

How did he die?

Pollock died aged 44 in a car crash.

Experiments with paint

Paul Jackson Pollock was the son of a land surveyor. He grew up in Arizona and California and studied art in New York. Pollock married the artist Lee Krasner, and the couple settled in Long Island, New York. Working in a large barn, Pollock developed his method of dripping paint onto a canvas stretched out on the floor. In 1951, Pollock stopped making drip paintings. He died in a car crash when he was 44, but in his last works he had begun to move away from abstract art.

Timeline

| 1912 | 1945 | c. 1946 | 1951 | 1956 |

Born 28 January in Cody, Wyoming, USA

Marries Lee Krasner

Starts producing drip paintings

Stops producing drip paintings

Dies 11 August in Springs, New York, USA

A new way of painting

For his drip paintings, Pollock usually fixed his canvas to the floor. Then he poured and dripped paint from a brush or directly from a can. He experimented with different kinds of paint, sometimes mixing it up with sand or broken glass. Instead of naming his paintings, he gave them numbers. Pollock was one of the leading members of the **Abstract Expressionist** movement.

Andy Warhol

Andy Warhol was an American painter, printmaker, and film-maker. He is famous for his images of products and celebrities.

A celebrity artist

Warhol was the son of poor **immigrants**. His parents had come to the United States from Europe. He was often ill as a child, and he spent a lot of time in bed, drawing pictures of film stars. He studied commercial art and worked in magazines and advertising. In the 1960s Warhol started to paint famous products, such as Campbell's soup cans. He also painted celebrities, including Marilyn Monroe. Later he changed from painting to printmaking.

What he said

66 I love plastic. I want to be plastic. 99

How did he die?

Warhol died from heart failure after an operation went wrong. He was 58 years old.

Timeline

Born 6 August in Pittsburgh, Pennsylvania, USA

Makes the film *Sleep*, showing a man sleeping

Dies 22 February in New York, USA

1928 **1960s** **1963** **1968** **1987**

Starts painting products and celebrities

Warhol is shot by Valerie Solanas

In 1968, Warhol was shot in his studio by an artist called Valerie Solanas. He was badly wounded but he survived. By the time of his death, Warhol was a celebrity in his own right.

Art and culture

Warhol wanted his art to reflect modern popular culture. So he deliberately showed mass-produced items. He also repeated some images he made with a small change of colour or background. He was a leading member of the **Pop Art** movement.

Find out more

This website looks at Warhol's childhood and early life:
www.warhola.com

View Warhol's famous prints of Marilyn Monroe at:
www.webexhibits.org/colorart/marilyns.html

Take a virtual tour of some of Warhol's work at:
www.region.sk/warhol/index2.html

27

Jean-Michel Basquiat

Jean-Michel Basquiat was a painter who started out as a graffiti artist, but later worked on canvases. His colourful paintings often contain images of violence.

What he said

" Since I was 17 I thought I might be a star. "

How did he die?

Basquiat died from a drug overdose at the age of 27.

Find out more

Find out all about Basquiat at this brilliant interactive site:
www.brooklynmuseum.org/
exhibitions/basquiat/street-to-studio/

This site traces all the stages of Basquiat's career:
www.brooklynmuseum.org/
exhibitions/basquiat

A short life

Basquiat came from an immigrant family. His father was Hawaiian and his mother was Puerto Rican. Basquiat showed an early talent for art. At the age of 17, he started spray-painting graffiti designs on buildings. The following year, he left school and went to live in New York City. He survived by selling T-shirts and postcards, but he also began painting on wood and canvases. Basquiat's work became popular, and he did some paintings with Andy Warhol (⇨p27). However, Basquiat was seriously addicted to drugs, and he also suffered from depression. As his art became more successful, his addiction got worse.

Timeline

1960	1977	1978	1980	1982	1988
Born 20 December in Brooklyn, New York, USA	Starts painting graffiti designs	Leaves home to live in New York City	Shows his paintings in his first exhibition	Meets and starts work with Warhol	Dies 12 August in New York City, USA

From graffiti to galleries

Basquiat is recognized as a leading black artist of his time, and many of his paintings explore the question of how it feels to be black. His colourful, expressive work combines text and images and is clearly influenced by his earlier graffiti designs.

Damien Hirst

Damien Hirst is a leading British artist. Many of his works explore the theme of death, and his best-known work is a skull covered with diamonds.

A new kind of art

Hirst studied fine art at Goldsmiths College in London. He is famous for works such as a shark preserved in a tank and his "spot paintings", which are made from rows of coloured circles. Hirst is married and has three sons.

Find out more

The White Cube gallery's guide to Hirst's life and art:
www.whitecube.com/artists/hirst

Learn more at:
www.whitecube.com/exhibitions/beyond_belief

Timeline

Born 7 June in Bristol, England

1965

Starts studying art at Goldsmiths College, London

Creates his shark in a tank

1986

1992

Wins the Turner Prize, a major British art award

Creates *For the Love of God*, a diamond-encrusted skull

1995

2007

Chris Ofili

The work of the British painter Chris Ofili reflects his Nigerian family background. He is famous for using elephant dung as a material in his work.

Art and Africa

Ofili studied at the Chelsea School of Art and the Royal College of Art in London. He is famous for using traditional African styles and materials in his paintings. In 1998, Ofili won the Turner Prize Award.

Timeline

Born in Manchester, England

1968

Starts studying at the Chelsea School of Art

Travels to Uganda to study African art

1988

1992

1998

Wins the Turner Prize, a major British art award

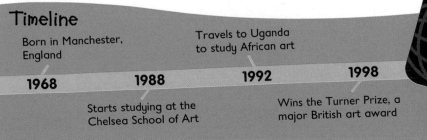

29

William Fox Talbot

William Fox Talbot was the first person to create artistic photographs. He also invented the photographic negative.

What he said

66 How charming… to cause these natural images to imprint themselves… upon the paper! 99

How did he die?

Fox Talbot died at home at Lacock Abbey, aged 77.

Find out more

This site presents an illustrated guide to Fox Talbot's life and work: www.metmuseum.org/TOAH/HD/tlbt/hd_tlbt.htm

Visit the website of the Fox Talbot Museum: www.nationaltrust.org.uk/main/w-vh/w-visits/w-findaplace/w-lacockabbeyvillage/w-lacockabbeyvillage-talbotmuseum.htm

Discover the story of Fox Talbot's experiments with photography at: www.rleggat.com/photohistory/history/talbot.htm

Science and photography

Fox Talbot came from a wealthy English family. He was a brilliant student at Cambridge University and he was fascinated by maths, physics, and chemistry. In the 1830s, he made his own camera and experimented with taking photographs. Fox Talbot took photographs of his home and garden, as well as views of Paris, Oxford, and York. He devoted many years to the art of photography.

Timeline

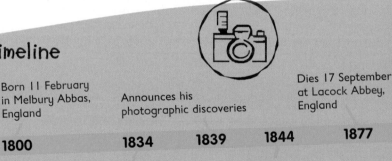

1800	1834	1839	1844	1877
Born 11 February in Melbury Abbas, England	Begins his photographic experiments	Announces his photographic discoveries	Writes *The Pencil of Nature*	Dies 17 September at Lacock Abbey, England

Discovering photography

The Frenchman Louis Daguerre is usually seen as the inventor of photography, but Fox Talbot is equally important. Daguerre created prints on metal plates, but Fox Talbot used a special kind of light-sensitive paper, which worked as a photographic negative. Fox Talbot went on to develop techniques for printing photographs. In the mid-1840s, Fox Talbot published the first book to be illustrated by photographs. It was called *The Pencil of Nature*.

Alfred Stieglitz

American photographer Alfred Stieglitz campaigned to make photography recognized as an art form.

Photographs as art

Stieglitz lived in New York until he was 17 but then moved to Germany. At the age of 29, he returned to New York and became a famous photographer. His work includes studies of his wife, the American artist Georgia O'Keeffe.

Find out more

Look at pictures of Steiglitz's work and find out about his life at: www.pbs.org/wnet/americanmasters/database/stieglitz_a.html

Timeline

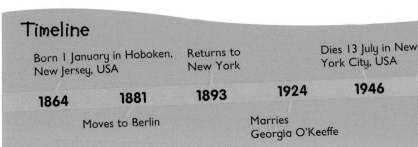

Born 1 January in Hoboken, New Jersey, USA — **1864**

Moves to Berlin — **1881**

Returns to New York — **1893**

Marries Georgia O'Keeffe — **1924**

Dies 13 July in New York City, USA — **1946**

Walker Evans

American **photojournalist** Walker Evans took photographs of poor people during the Great Depression.

Picturing people

Evans wanted to be a writer but turned to photography. In the 1930s, he recorded the lives of poor farm workers in Alabama during the Great Depression.

Find out more

This site includes lots of photographs taken by Evans: www.getty.edu/art/gettyguide/artMakerDetails?maker=1634

Timeline

Born 3 November in St. Louis, Missouri, USA — **1903**

Takes up photography — **1930**

Starts photographing farm workers in Alabama — **1936**

Begins work on "subway portraits" — **1938**

Dies 10 April in New Haven, Connecticut, USA — **1975**

Bill Brandt

Bill Brandt was a photojournalist and art photographer. He is famous for his images of British people in London during World War II.

What he said

66 It is part of the photographer's job to see more intensely than most people do. 99

How did he die?

Bill Brandt died after a short illness, aged 79.

Picturing the British

Brandt grew up in Germany. At the age of 16, he developed a serious lung disease and spent the next six years recovering. At the age of 22, he joined his brother in Vienna, Austria, and started to train as a photographer. He worked briefly in Paris, France, as an assistant to the art photographer Man Ray before moving to London. There, he began to photograph people from all classes of British society. During World War II, Brandt was commissioned to photograph people sheltering from the bombing in Underground stations. After the war, he continued to record British life and also produced photographic portraits, landscapes, and nudes.

Timeline

| 1904 | 1926 | 1933 | 1940 | 1951 | 1983 |

Born 3 May in Hamburg, Germany

Starts to train as a photographer

Moves to London

Starts photographing Londoners at war

Publishes *Literary Britain*

Dies 20 December in London, England

Journalism and art

For 50 years, Brandt was one of Britain's leading photojournalists. He was also recognized as an important art photographer. Brandt was fascinated by the effects of light and specialized in photography at night. His collections of photographs include *The English at Home* and *Literary Britain*.

Henri Cartier-Bresson

The French photographer Henri Cartier-Bresson is famous for his images of life on the streets. He is often called "the father of photojournalism".

A photojournalist's life

Cartier-Bresson came from a wealthy family who lived in Paris, France. At first Cartier-Bresson studied painting, but at the age of 23 he turned to photography. Within a few years he was working as a photojournalist. During World War II, Cartier-Bresson spent three years as a prisoner of war, before he managed to escape. After the war, he helped to set up the Magnum photo agency, which sent photographers all over the world. Cartier-Bresson photographed many significant world events, including Mahatma Gandhi's funeral. He also worked in film as the assistant to director Jean Renoir in the 1930s. He is best-known for his images of poor people in Paris.

What he said

66 The photograph itself doesn't interest me. I want only to capture a minute part of reality. 99

When did he die?

Cartier-Bresson died at the age of 93 after a long and healthy life.

Timeline

1908	1931	1937	1983
Born 22 August in Chanteloup-en-Brie, France	Takes up photography	Starts work as a photojournalist	Dies 3 August in Céreste, France

Find out more

Find out more about the life of Cartier-Bresson at: www.henricartierbresson.org

Search for Cartier-Bresson's images at: www.magnumphotos.com/Archive

Take a virtual tour of some of Cartier-Bresson's portraits: www.npg.si.edu/exh/cb

Candid camera

Cartier-Bresson was one of the first great photojournalists. He was also one of the first photographers to take candid pictures — images of people who did not know that they were being photographed. He advised other photographers to wait patiently for "the decisive moment" and then act fast to take the perfect picture.

Don McCullin

Don McCullin, a British photojournalist, is famous for his images of violence and disaster. McCullin's best-known images show conflict in Vietnam and Northern Ireland.

Photos of conflict

As a young man McCullin photographed scenes of violence on the streets of north London. His talent was recognized by a national newspaper. For 18 years he has worked as a photojournalist, taking pictures of wars and disasters.

Find out more

This site includes an interview with McCullin:
http://easyweb.easynet.co.uk/~karlpeter/zeugma/inters/mccullin.htm

Timeline

1935	1958	1966	1984	2005
Born 9 October in London, England	Photographs gangs in north London	Starts working for the Sunday Times	Stops working on overseas news stories	Publishes Don McCullin in Africa

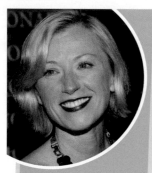

Cindy Sherman

An American art photographer and film director, Cindy Sherman is famous for taking photographs of herself dressed in a range of different disguises.

Portraits in disguise

In the 1970s, Sherman developed the idea of creating a series of self-portraits. Her first series included 69 self-portraits dressed as different film stars. She has worked as a film director and created a series of fashion advertisements.

Find out more

This site traces Sherman's career as an artist:
www.cindysherman.com

Timeline

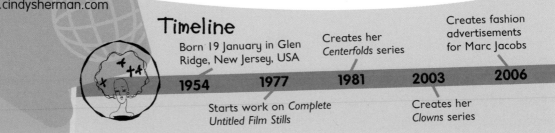

1954	1977	1981	2003	2006
Born 19 January in Glen Ridge, New Jersey, USA	Starts work on Complete Untitled Film Stills	Creates her Centerfolds series	Creates her Clowns series	Creates fashion advertisements for Marc Jacobs

Filippo Brunelleschi

Filippo Brunelleschi was a great Renaissance architect. He helped to reintroduce the classical style of architecture in Italy.

Architect and artist

For almost 30 years, Brunelleschi built the dome of Florence Cathedral. Brunelleschi was also a sculptor and an artist. He introduced the use of **perspective** into Renaissance art.

Timeline

Born in Italy, probably in Florence

Designs the first classical building in Florence

Dies 15 April in Florence, Italy

1337 c. **1400** **1402** **1419** **1446**

Travels to Rome to study ancient buildings

Starts to design the dome of Florence Cathedral

Sir Christopher Wren

Sir Christopher Wren was an English architect who worked in a classical style. He designed St. Paul's Cathedral and many London churches.

Rebuilding London

Wren began designing buildings in his thirties. Following the Great Fire of London in 1666, Wren designed the new St Paul's Cathedral as well as more than 50 London churches.

Find out more

Learn more about Wren's life and work of Wren at:
www.bbc.co.uk/history/
historic_figures/
wren_christopher.shtml

Timeline

Born 20 October in East Knoyle, England

Designs his first building

Works for King Charles I

1632 **1657** **1663** **1666** **1669** **1723**

Becomes a professor of astronomy

Starts work on St. Paul's Cathedral

Dies 25 February in London, England

Antoni Gaudí

The Spanish architect Antoni Gaudí is famous for creating unusual buildings that were decorated with sculpture and mosaics. Gaudí's most famous building is the Sagrada Familia Cathedral in Barcelona, Spain.

An architect's life

Gaudí was the son of a metalworker. He grew up in the Spanish countryside and learnt a lot about animals and plants. After he had finished his training as an architect, he designed many buildings, mostly in the city of Barcelona. Gaudí never married. Instead he lived with his father and his niece. He was an extremely religious person, and he chose to live in relative poverty. For the last 15 years of his life, he worked full time on the cathedral of the Sagrada Familia.

What he said

" God's Creation continues incessantly through the media of man. "

How did he die?

Gaudí was run over by a tram and died in hospital three days later.

Timeline

Born 25 June in the Tarragona region of Spain

Starts to design the cathedral of Sagrada Familia

Dies 10 June in Barcelona

1852 **1868** **1883** **1911** **1926**

Moves to Barcelona to study architecture

Decides to work full time on Sagrada Familia

Find out more

This site looks at Gaudí's work and includes some pictures of his buildings:
www.gaudidesigner.com

Explore Gaudí's Sagrada Familia Cathedral:
www.sagradafamilia.org

Discover lots of information about Gaudí and his architecture:
www.gaudi2002.bcn.es/english

Gaudí's masterpiece

Gaudí designed the cathedral of the Sagrada Familia both inside and out. He worked in the **Art Nouveau** style, but his designs were also inspired by Gothic architecture and by forms in nature. Gaudí planned that the cathedral would have a total of 18 towers. The building is still not finished today.

Frank Lloyd Wright

Frank Lloyd Wright believed that buildings should be inspired by nature. One of his most famous buildings is the Guggenheim Museum in New York.

An eventful life

Wright grew up in Wisconsin in the USA. As a young man, he moved to Chicago and trained to become an architect. He designed a family home in Oak Park, from where he ran his businesses. In 1911, Wright built a new home, called Taliesin, where he lived with his partner, Mamah. Three years later, one of the servants at Taliesin murdered Mamah and six other people and then set the house on fire. Wright somehow recovered from this tragedy and rebuilt Taliesin. At the age of 69, Wright moved to a new home in Arizona. Altogether, he married three times and had seven children.

What he said

66 Study nature, love nature, stay close to nature. It will never fail you. 99

Find out more

Take a virtual tour of Frank Lloyd Wright's life and buildings. This site includes video clips of interviews with the architect: www.pbs.org/flw

Take another virtual tour of his work at: www.loc.gov/exhibits/flw

Find out more about Lloyd Wright at: www.delmars.com/wright/flwright.htm

Timeline

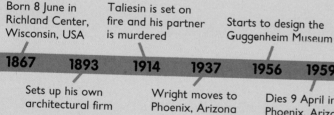

Born 8 June in Richland Center, Wisconsin, USA

Taliesin is set on fire and his partner is murdered

Starts to design the Guggenheim Museum

1867 1893 1914 1937 1956 1959

Sets up his own architectural firm

Wright moves to Phoenix, Arizona

Dies 9 April in Phoenix, Arizona

How did he die?

Lloyd Wright died at home at the age of 91.

Buildings and nature

Lloyd Wright built churches, houses, museums, and schools. He liked to use natural materials and often copied forms from nature. For example, the spiral design for the Guggenheim Museum in New York was based on a snail's shell. He also built skyscrapers that looked like trees.

Le Corbusier

Le Corbusier was a Swiss architect who used concrete, glass, and steel in apartment blocks, house, chapels, and schools. He also developed new ideas for urban living.

Designs for living

Le Corbusier studied architecture in Switzerland. In 1914 he began to design open-plan houses. After World War I, he settled in France. His best-known work is the Unité d'Habitation — an urban community in Marseille, France.

Timeline

	Designs his first open-plan house		Completes the Unité d'Habitation in Marseille	
1887	**1914**	**1922**	**1952**	**1965**
Born 6 October in La Chaux-de-Fonds, Switzerland		Opens a design studio in Paris	Dies 27 August in Roquebrune-Cap-Martin, France	

Sir Richard Rogers

British architect Sir Richard Rogers is famous for his functionalist designs, such as the Pompidou Centre in Paris and the Millennium Dome in London.

An architect's career

Rogers studied architecture in Britain and the USA. His first famous building was the Pompidou Centre in Paris, which was built in the early 1970s. He is one of the architects chosen to design Tower3 in the new World Trade Tower in New York.

Find out more

Visit the official website of Rogers and partners:
www.richardrogers.co.uk

Timeline

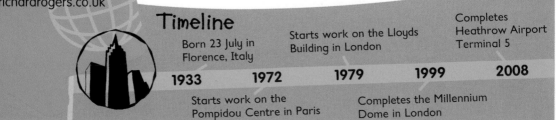

	Born 23 July in Florence, Italy	Starts work on the Lloyds Building in London		Completes Heathrow Airport Terminal 5
1933	**1972**	**1979**	**1999**	**2008**
	Starts work on the Pompidou Centre in Paris		Completes the Millennium Dome in London	

William Morris

William Morris was a British designer of **textiles**, wallpaper, stained glass, and other decorative arts. He was one of the founders of the **Arts and Crafts Movement**.

Many talents

As a young man, Morris began to train as an architect, but he soon discovered that his real interest lay in decorative arts. At the age of 26, he moved into a new house with his young wife. Morris hated factory-made furnishings, so he decided to furnish the house with the help of a group of friends. Morris and his friends set up a company to design carpets, curtains, metalwork, stained glass, and tapestry. Morris continued to run his design company throughout his life. He never stopped creating new designs, and he also set up a printing press.

Timeline

Born 24 March in Walthamstow, England

Starts Morris, Marshall, Faulkner and Company

Dies 3 October in London, England

1834 **1860** **1861** **1891** **1896**

Moves to Red House, Bexleyheath, and starts to decorate it

Sets up the Kelmscott Press to print beautiful books

Arts and Crafts

Throughout his life, Morris campaigned for a return to the methods used by traditional craftworkers. He helped to create the Arts and Crafts Movement, which flourished between 1880 and 1910.

What he said

66 Have nothing in your houses that you do not know to be useful, or believe to be beautiful. 99

Find out more

The website of the William Morris Society at: www.morrissociety.org

This site provides a useful guide to Morris's life and work: www.huntington.org/ArtDiv/morris.html

Take a virtual tour of some of Morris's designs at: http://morris.artpassions.net

Explore another great site on Morris: www.huntington.org/ArtDiv/Morris2003/Morris2003.html

How did he die?

Morris died after a short illness at the age of 62

39

Louis Comfort Tiffany

Louis Comfort Tiffany was an American designer who is famous for his stained glass. Tiffany was a leading member of the Art Nouveau movement.

What he said

❝ Because a thing has always been done in a certain way is no reason why it should never be done in any other. ❞

How did he die?

Tiffany died at home at the age of 85. By that time, his designs were no longer in fashion.

Find out more

Take a virtual tour of Tiffany's work at:
www.metmuseum.org/
explore/Tiffany/index.html

Visit the website of the Charles Hosmer Morse Museum of American Art which includes a comprehensive collection of Tiffany's works:
www.morsemuseum.org

A website devoted to Tiffany lamps:
www.antiquesandfineart.com/
articles/article.cfm?request=167

A designer's life

Tiffany was the son of Charles L. Tiffany, who founded the Tiffany jewellery company. Louis did not enter the family firm straight away, but instead trained to be a painter. At the age of 27, he became interested in glassmaking. He set up a glass company with friends and later founded his own firm. At first, Tiffany concentrated on stained glass windows. In the 1890s, he began to design and make lamps. His company was a great success. During the early years of the 20th century, the craze for Tiffany lamps swept through the USA and Europe.

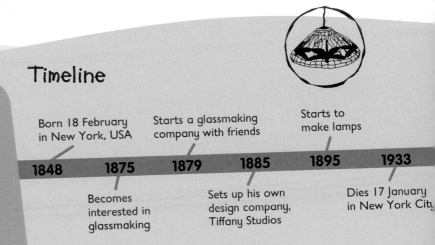

Timeline

Born 18 February in New York, USA

Starts a glassmaking company with friends

Starts to make lamps

1848 **1875** **1879** **1885** **1895** **1933**

Becomes interested in glassmaking

Sets up his own design company, Tiffany Studios

Dies 17 January in New York City

Tiffany glass

Tiffany created glass with clear, bright colours. He also developed a new kind of glass that was not completely see-through. Tiffany called his new glass "favrile glass". As well as designing windows and lamps, Tiffany also created vases, jewellery, and mosaics in the Art Nouveau style.

Coco Chanel

The French fashion designer Coco Chanel created simple but stylish designs for women. She founded the Chanel fashion house.

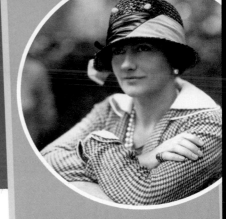

A woman of style

Chanel came from a very poor family, and her mother died when she was six years old. As a young woman Gabrielle worked as a singer, using the nickname "Coco". She always dressed elegantly and had many admirers who helped her with her business. In 1913, she opened a shop in Paris, France, mainly selling hats. Over the next ten years, Chanel opened more shops and began to design a wide range of women's fashions. During World War II, Chanel closed her shops. After the war, her designs were even more popular.

What she said

66 Simplicity is the keynote of all true elegance. 99

How did she die?

Chanel died in her private suite in the Ritz Hotel, at the age of 87.

Timeline

1883	1905	1913	1954	1971
Born 19 August in Saumur, France	Works as a singer in cafes	Opens a shop in Paris	Starts designing again, after World War II	Dies 10 January in Paris

Classic fashions

Chanel introduced simple and casual styles for women. She often copied features from men's clothing. She is famous for her elegant suits with big buttons. She also created "the little black dress", which is a simple, strapless dress. Many of her designs became fashion classics.

41

Sir Terence Conran

Sir Terence Conran is a British designer who specializes in furniture and textiles. He founded the Habitat stores, selling inexpensive home furnishings.

A life in design

Conran studied textile design at art college. He started his own furniture-making company aged 21, and 12 years later he opened the first Habitat store. He has been involved in many aspects of product design and has written several books on design.

Find out more

Visit the official website of the Conran company, with many examples of Conran's designs:
www.conran.com

Timeline

	Sets up his own furniture-making business			Opens the first Habitat store	
1931	**1952**	**1956**		**1964**	**1999**
Born 4 October in Kingston-upon-Thames, England		Starts his own design company		Opens a Conran Shop in New York, USA	

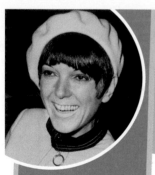

Mary Quant

Mary Quant is a British fashion designer, who helped to create the styles of the "Swinging Sixties". Quant is best-known for her miniskirts and hot pants.

Styles of the sixties

Quant started in fashion by opening a shop on the King's Road, in London. Her designs were popular and she soon had her own fashion label. Quant designed patterned tights, plastic raincoats, and "paint-box" make-up as well as her famous miniskirts and hot pants.

Find out more

View the official Mary Quant website to see a picture history of her designs:
www.maryquant.co.uk

Timeline

	Born 11 February in Kent, England		Launches the Ginger group to sell her designs worldwide
1934		**1955**	**1963**

Opens a shop on the King's Road, Chelsea, in London

Calvin Klein

Calvin Klein is an American fashion designer who worked his way up the clothing business. He is best-known for his jeans and underwear.

Early career

Klein came from a family of Jewish immigrants. As a teenager, he developed a passion for fashion and drawing. He studied at the New York Fashion Institute and worked as an apprentice in a tailor's company. At the age of 26, he began his own fashion company with a childhood friend. A New York department store gave Klein a large order, and his new company expanded rapidly. Klein created a range of designs for women and men, but specialized in designer sportswear.

What he said

" I make sports clothes that are relatively conservative, clothes that everyone wears. "

Find out more

Visit the official website of the Calvin Klein company: www.calvinklein.com

Find out more about Calvin Klein's career at: www.thebiographychannel.co.uk/biography_home/298:0/Calvin_Klein.htm

This site includes lots of useful information about Klein's life and designs: www.infomat.com/whoswho/calvinklein.html

Timeline

Born 19 November in New York City, USA

Sets up his company

Starts to design men's underwear

1942 **1962** **1968** **1970s** **1982**

Starts work at a tailor's company

Launches his adverts for jeans

A fashion success

By the mid 1970s, Klein's company was an international business empire. His designs for stretch jeans were popular, and he launched a very successful advertising campaign. In the 1980s, he started to design men's underwear. Until this time, men's underwear had been merely functional. Today, Calvin Klein designs clothes for men, women, and children. He creates perfumes and cosmetics and designs for home decoration. He has been married twice and has one daughter.

Did you know?

Klein sold 200,000 pairs of his tight-fitting jeans in the first week of their sale in 1974.

Gianni Versace

The Italian designer Gianni Versace created dramatic fashions. His clothes were worn by royalty and celebrities.

What he said

"I like the body. I like to design everything to do with the body."

How did he die?

Versace was shot dead on the steps of his American beach house. He was 50.

Getting started

Versace's mother ran a small dressmaking business. As a young boy, he helped his mother with her work. He found jewels and braid to decorate his mother's dresses and even designed some of the clothes himself. When he was 25, Versace moved to Milan, Italy, and worked as a designer for a range of fashion houses. Within six years, he had launched his own collections for women and men. By the mid 1980s, he was running an international fashion empire.

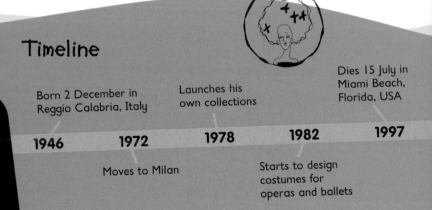

Timeline

- Born 2 December in Reggio Calabria, Italy
- Launches his own collections
- Dies 15 July in Miami Beach, Florida, USA

1946 — 1972 — 1978 — 1982 — 1997

- Moves to Milan
- Starts to design costumes for operas and ballets

Striking designs

Versace is considered to be one of the most talented fashion designers of the late 20th century. He created fashions for women and men and stage clothes for celebrities such as Madonna and Elton John. He also designed costumes for opera and ballet. In his colourful and dramatic designs, he was influenced by Greek and Roman art and also by modern abstract painting.

Stella McCartney

Stella McCartney is an English fashion designer. She creates glamorous outfits for the stars, but has also designed for high street stores. She is also a passionate supporter of animal rights.

A talent for fashion

McCartney is the daughter of Paul McCartney (of the Beatles) and his first wife, Linda. Stella started to design clothes at the age of 12. She worked for several years as an apprentice in the fashion industry before studying fashion at St Martin's College, London. For her graduation show at the end of her course, her clothes were modelled by her friends, the supermodels Naomi Campbell and Kate Moss. Two years later, she was chosen to be the chief designer of the Paris fashion house, Chloé. After three years, McCartney left Chloé and started a joint project with the Gucci company. In 2005, she started work with Adidas, designing sportswear for women.

What she said

" The one thing I have going for me is that I'm exactly the age bracket of the person who buys my clothes. "

Did you know?

McCartney has three children with her husband, publisher Alasdhair Willis.

Timeline

Born 13 September in London, England — 1971

Becomes the chief designer at Chloe — 1997

Starts a joint project with Gucci — 2001

Starts designing for Adidas — 2004

Starts designing handbags for Le Sportsac — 2008

Find out more

Visit McCartney's official website, which includes great examples of her designs: www.stellamccartney.com

This site has lots of information about McCartney's career, including quotes from Stella herself: www.notablebiographies.com/news/Li-Ou/McCartney-Stella.html

Find out more information about McCartney at: www.infomat.com/whoswho/stellamccartney.html

McCartney designs

McCartney is a strict vegetarian, and she does not use fur or leather in her designs. She creates glamorous clothes for rock stars, as well as clothes for ordinary women. One of her most famous designs was Madonna's wedding dress.

45

Glossary

abstract Showing an idea rather than a thing.

Abstract Expressionism Style in art, in which artists use colour and form to express powerful feelings. The Abstract Expressionist movement began in the USA in the 1940s.

Art Nouveau Style in art and design, in which artists use swirling shapes based on natural forms. The Art Nouveau movement began in France in the 1890s.

Arts and Crafts movement Movement in design and architecture, in which artists aim to return to old-fashioned, traditional methods. The Arts and Crafts movement began in Britain and the USA at the end of the 19th century.

classical In the style of ancient Greece or Rome.

commission To pay an artist to create a work of art.

communism Way of running a country in which the government owns all the country's land and factories, and the profits are shared by everyone.

Cubism Style in art and sculpture, in which artists build up their images using geometric shapes, such as triangles and circles. The Cubist movement began in France in the early 20th century.

domestic To do with the home and the family.

Expressionism Style in art, in which artists aim to show powerful feelings through their work.

frescoes Paintings on walls.

immigrants People who arrive from abroad to live permanently in a country.

Impressionism Style in art, in which artists aim to show the impression that something makes on their senses. The Impressionist movement began in France in the 1860s.

influenza Illness that gives you a high temperature and makes you feel very weak. Influenza is often known as flu.

Madonna Virgin Mary, mother of Jesus Christ.

minister Clergyman or priest.

patron Someone who gives money and support to an artist.

perspective Method used by artists to show things in the distance.

photojournalist Photographer who tells a story through photographs.

pneumonia Serious illness that affects the lungs, making it very hard for the sufferer to breathe.

Pop Art Style in art, in which artists copy the style of advertisements, comics and popular culture. The Pop Art movement began in the 1950s in Britain and the USA.

Post-Impressionism Term used to describe the work of a group of artists who responded to the Impressionist movement by using very bold colours and shapes in their art.

realism Method used by artists to make things look as real as possible.

Renaissance Movement in art, architecture and learning that was inspired by the art and culture of Ancient Greece and Rome. The Renaissance began in Italy in the 14th century.

stroke Sudden damage to the brain that often causes part of the body to become paralysed.

Surrealism Style in art, in which artists show dreamlike images. The Surrealist movement began in France in the 1920s.

symbol Object that acts as a sign, standing for something else.

textiles Fabrics or materials.

woodcut Print made from a block of wood with a design carved on it. The wood block is covered with ink and pressed onto paper to create a print.

Index